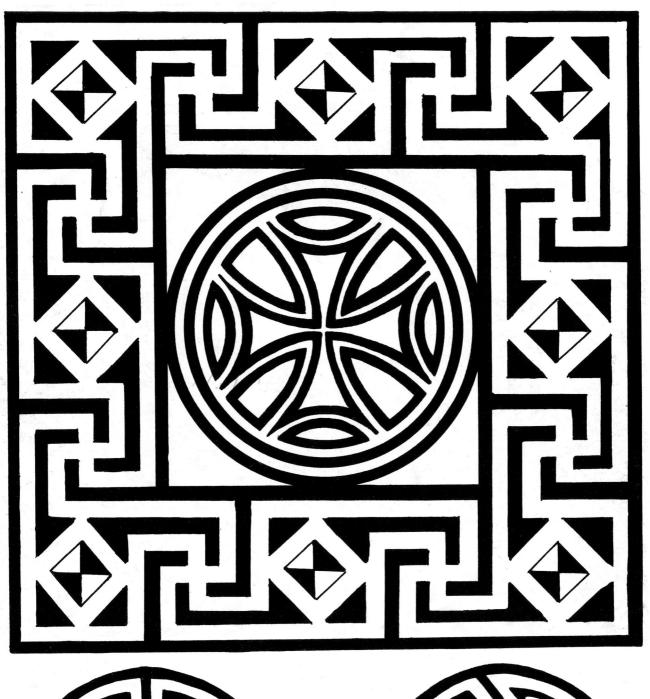

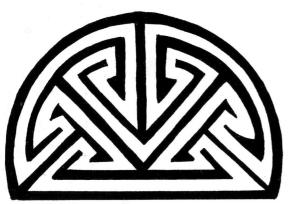

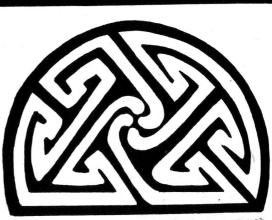

BRAINSE MHEAL RATH LUIRC CHARLEVILLE MALL LIBRARY TEL. 8749619

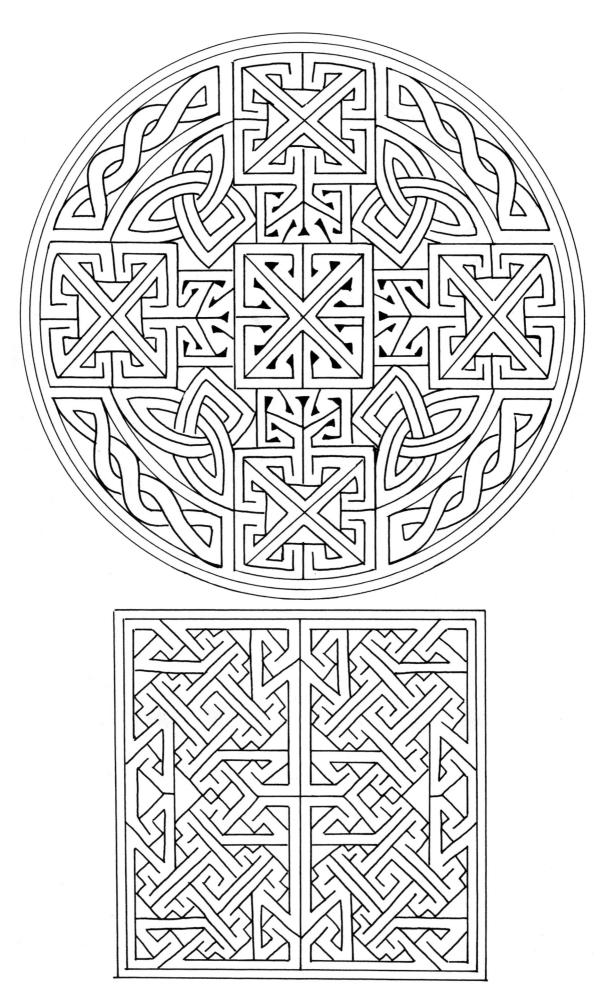

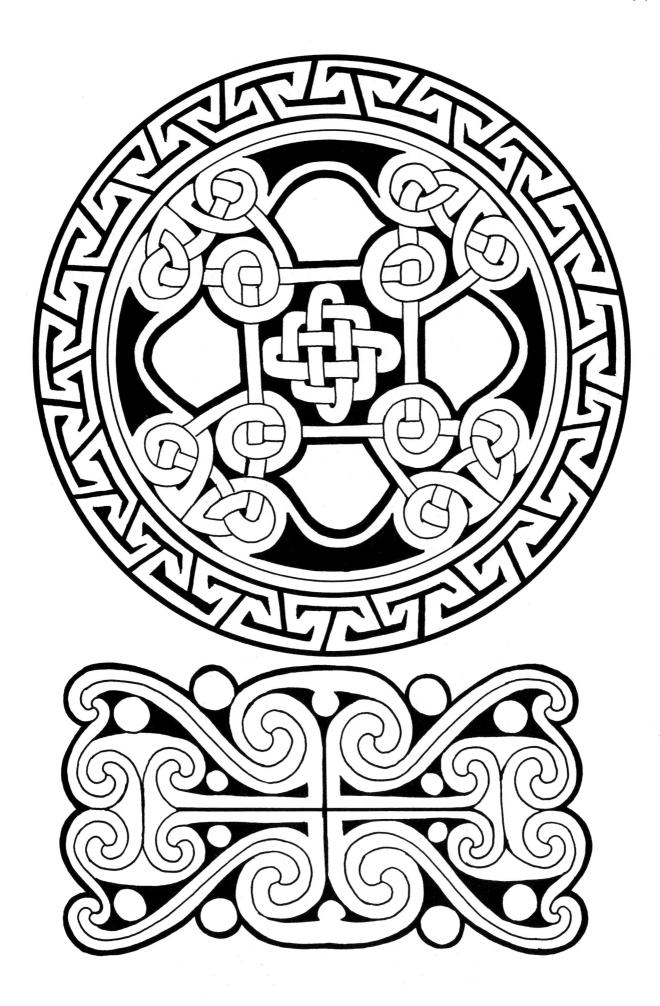

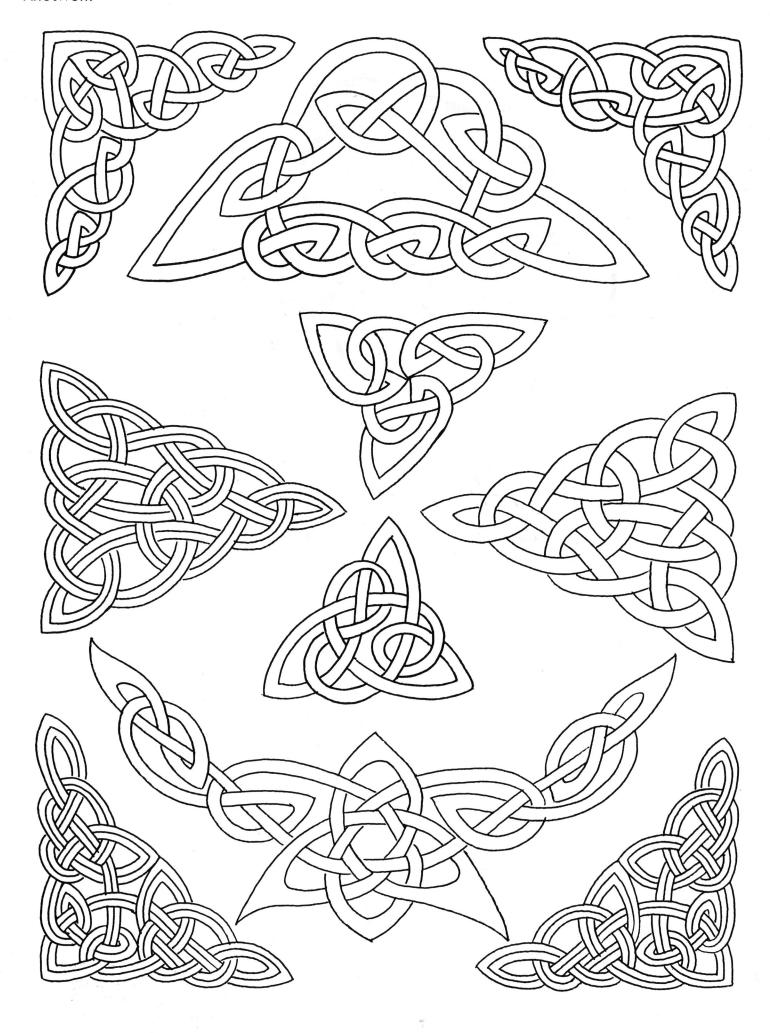

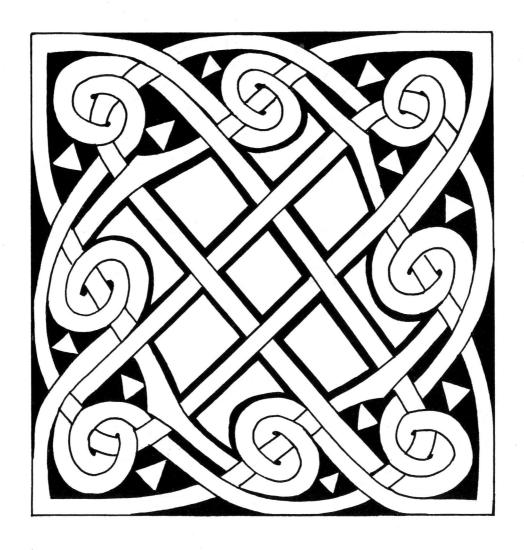

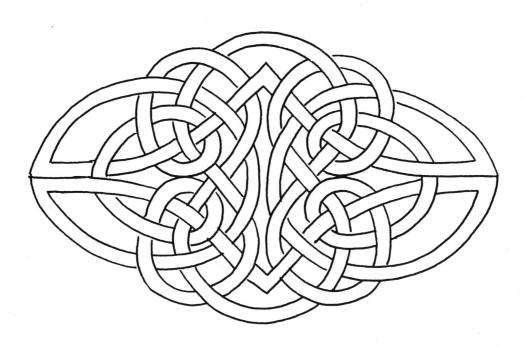

BRAINSE MHEAL RATH LUIRC CHARLEVILLE MALL LIBRARY TEL. 8749619

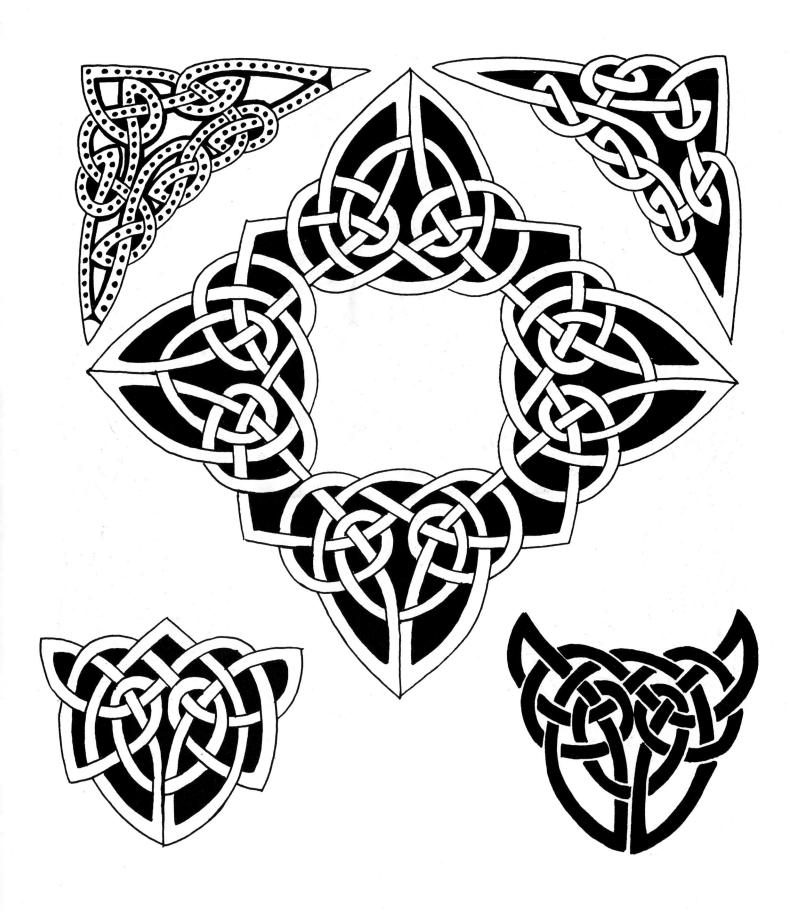

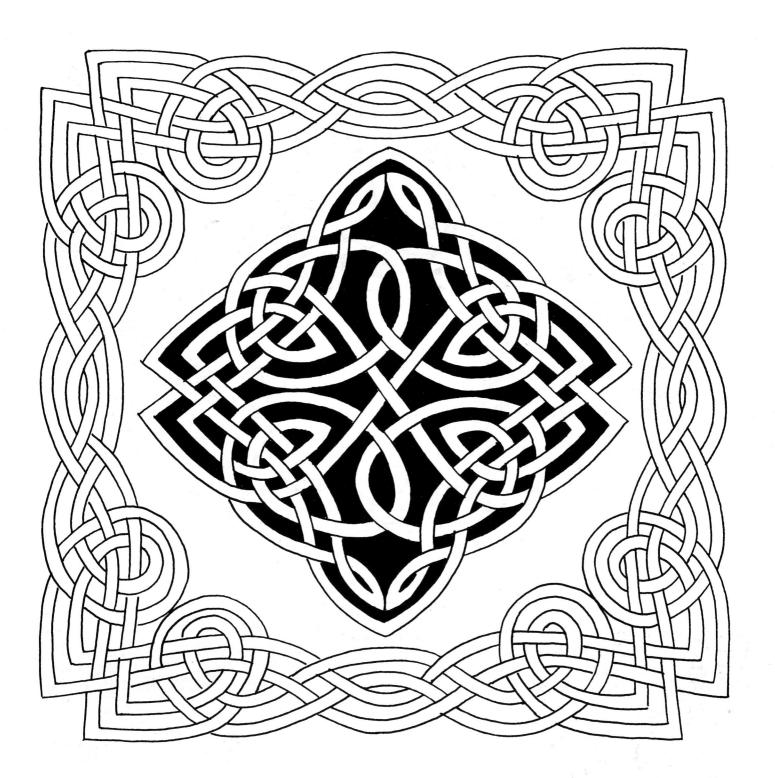

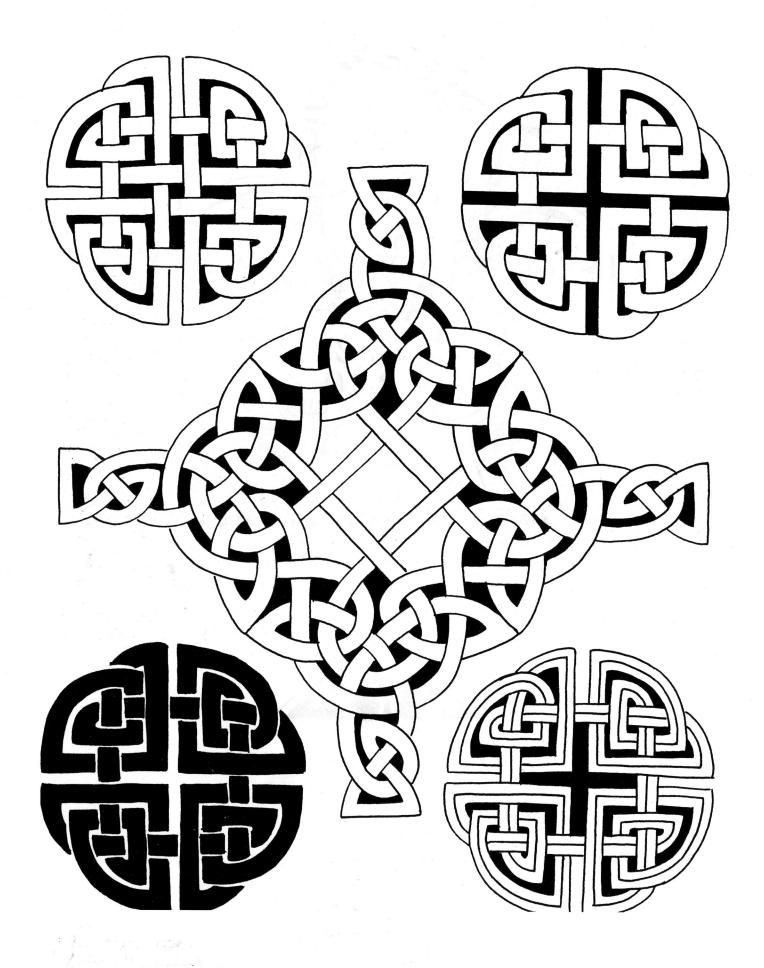

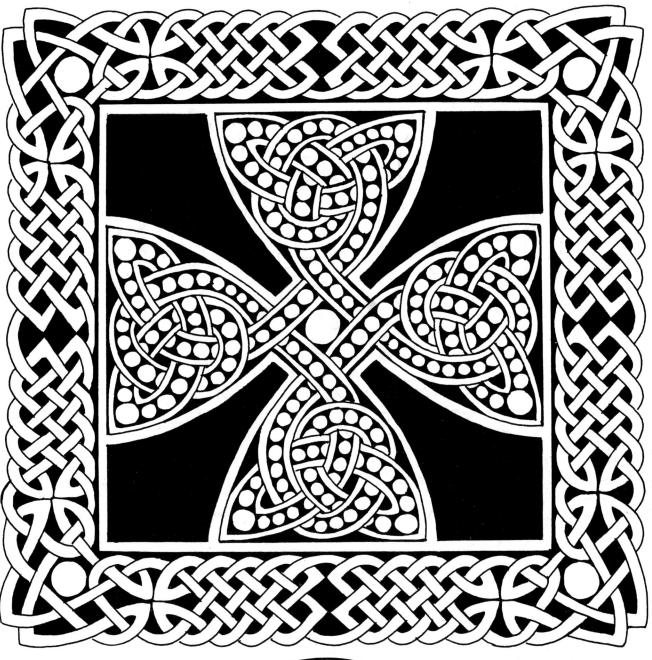

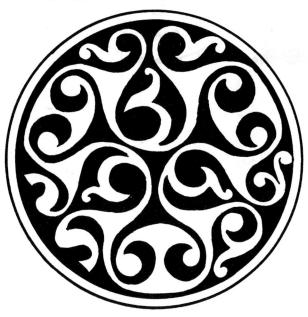

BRAINSE MHEAL RATH LUIRC CHARLEVILLE MALL LIBRARY TEL. 8749619

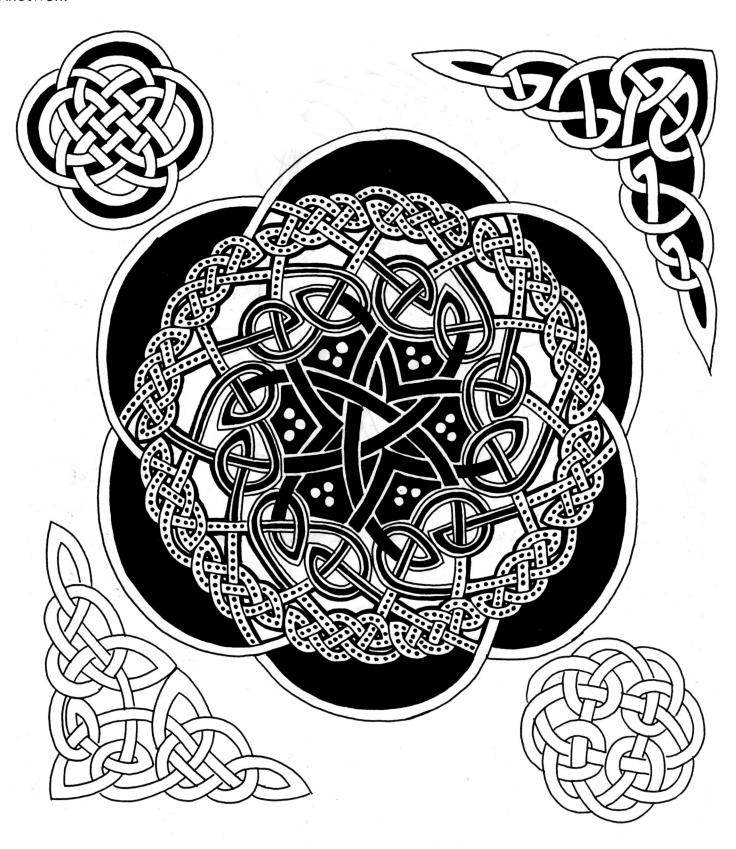

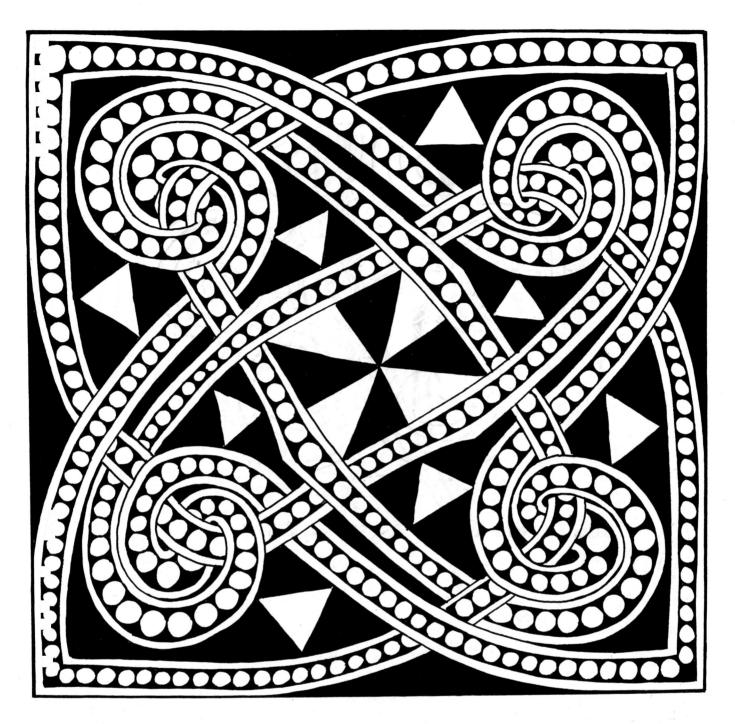

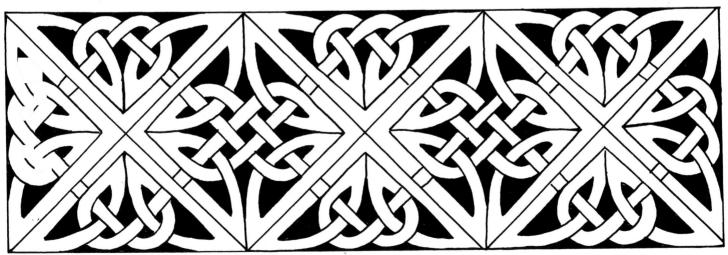

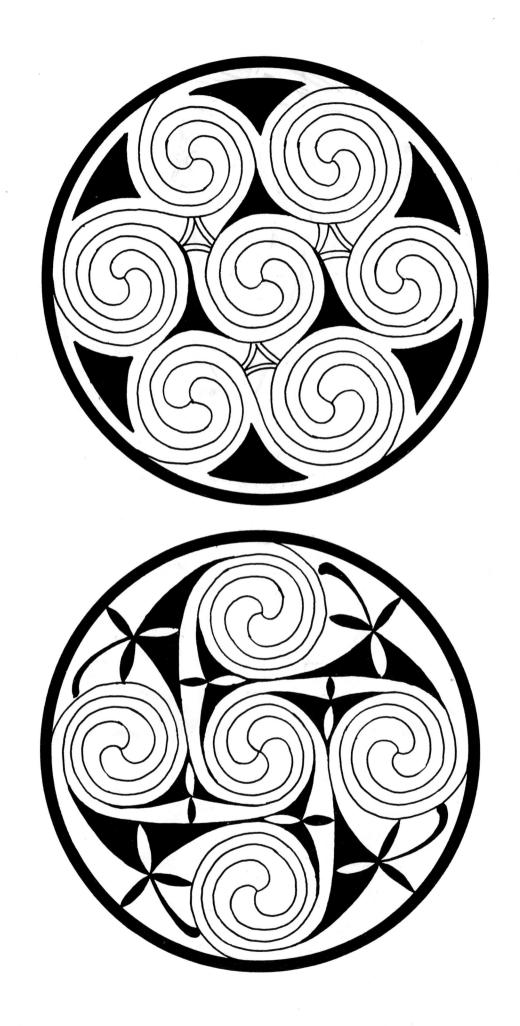

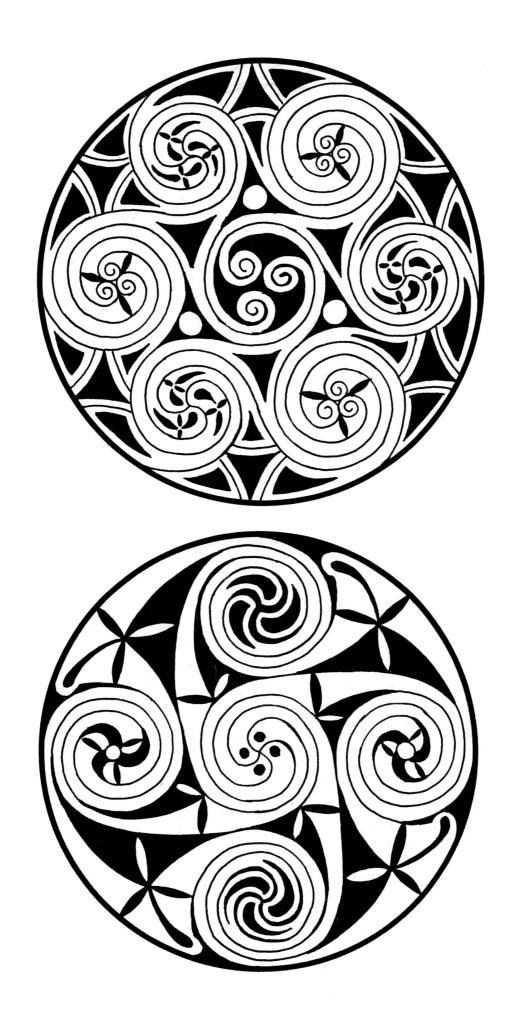

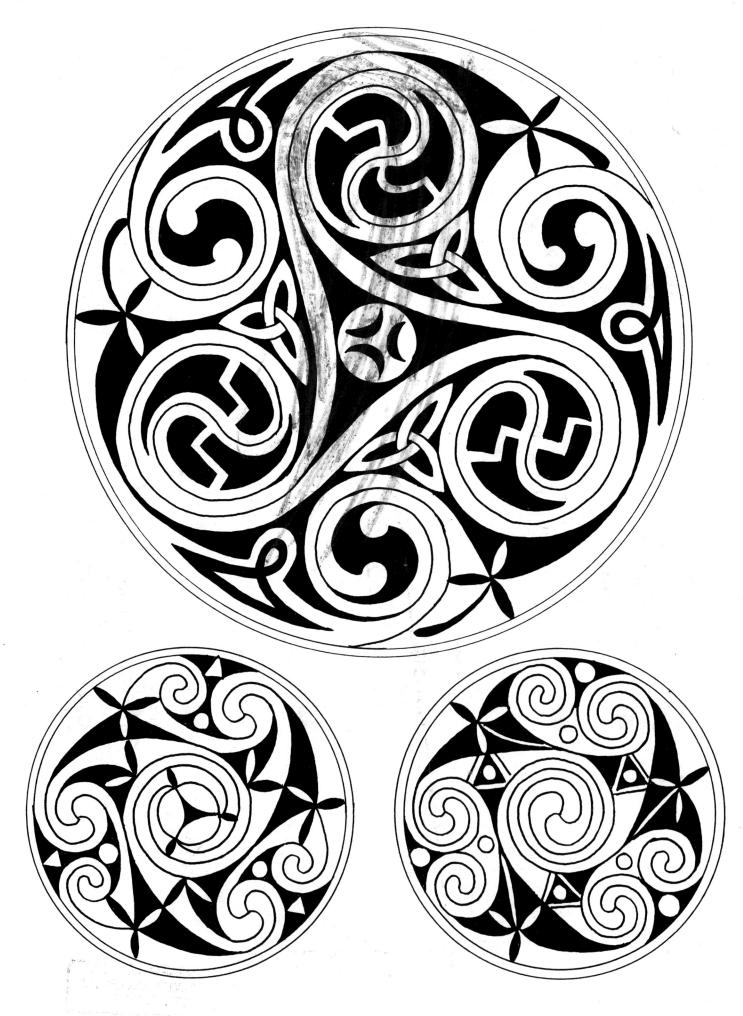

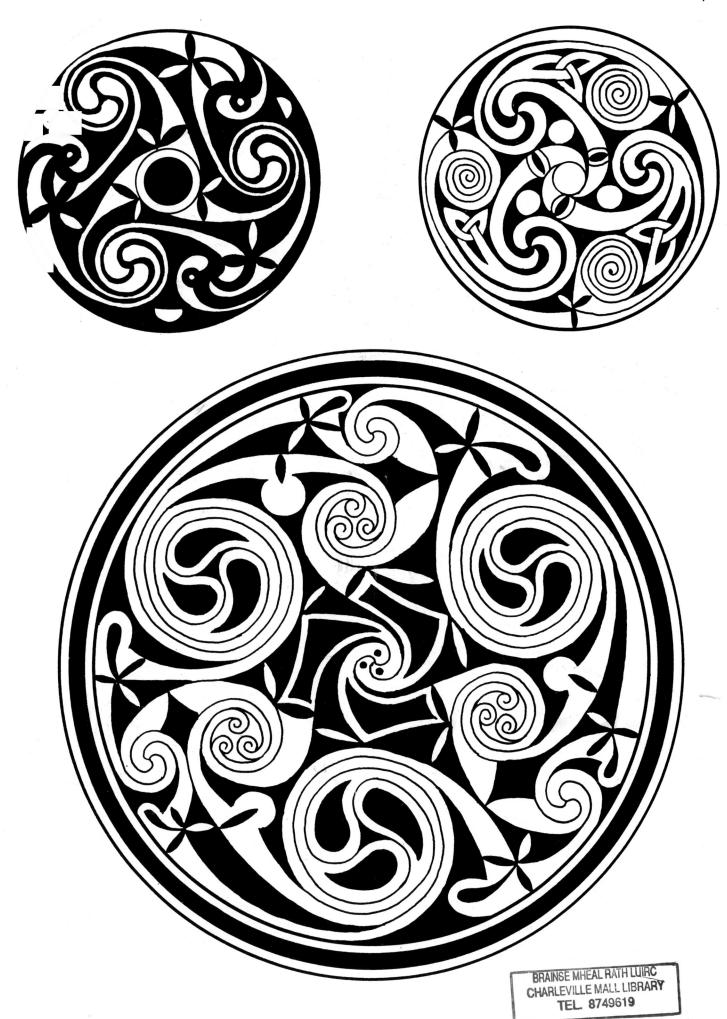

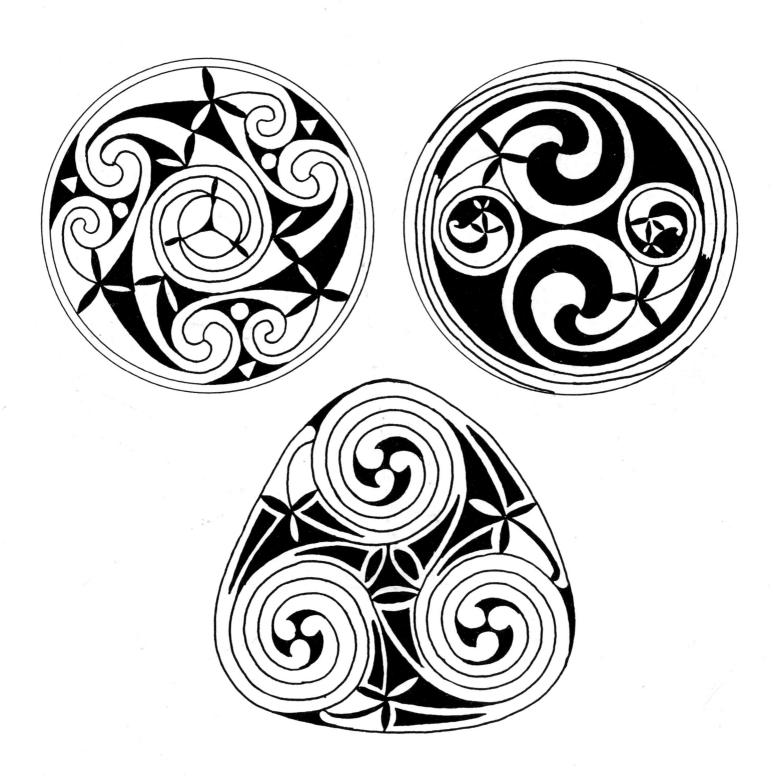

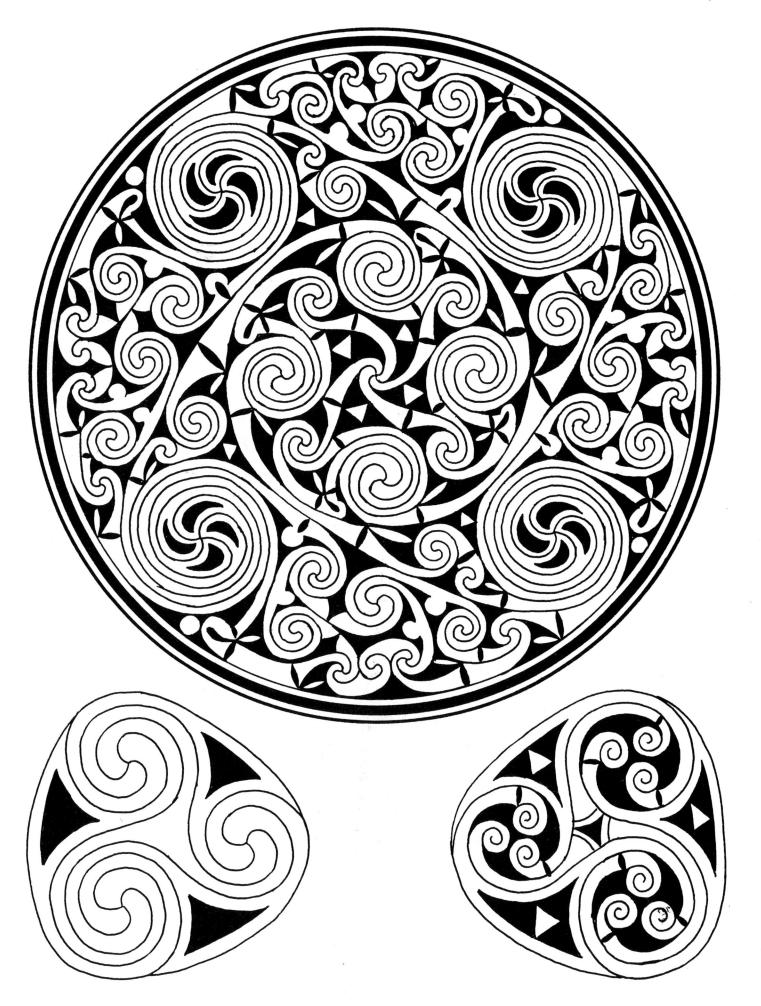

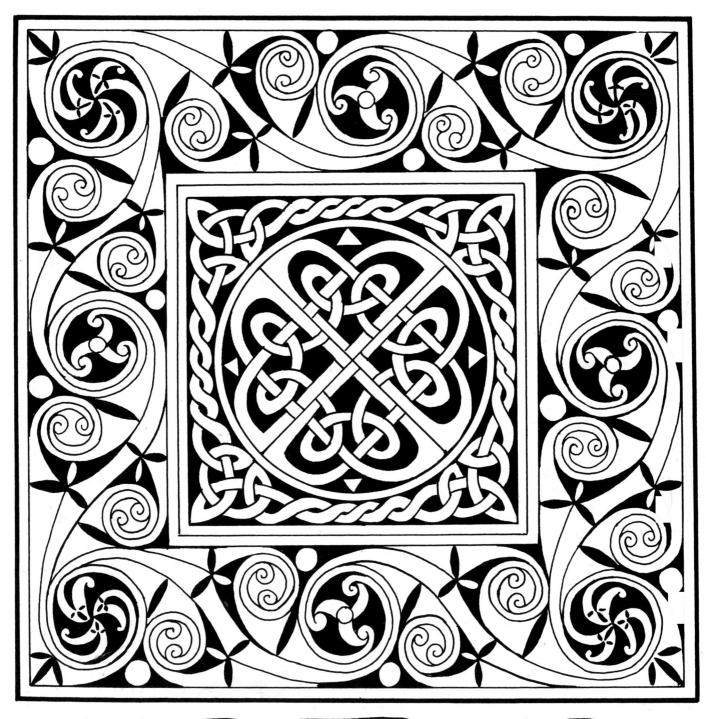

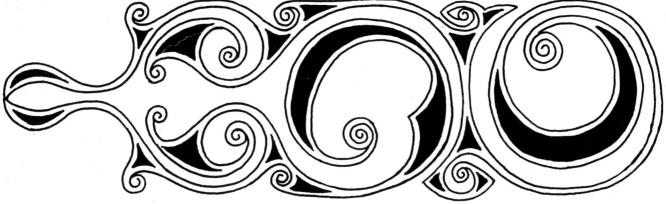

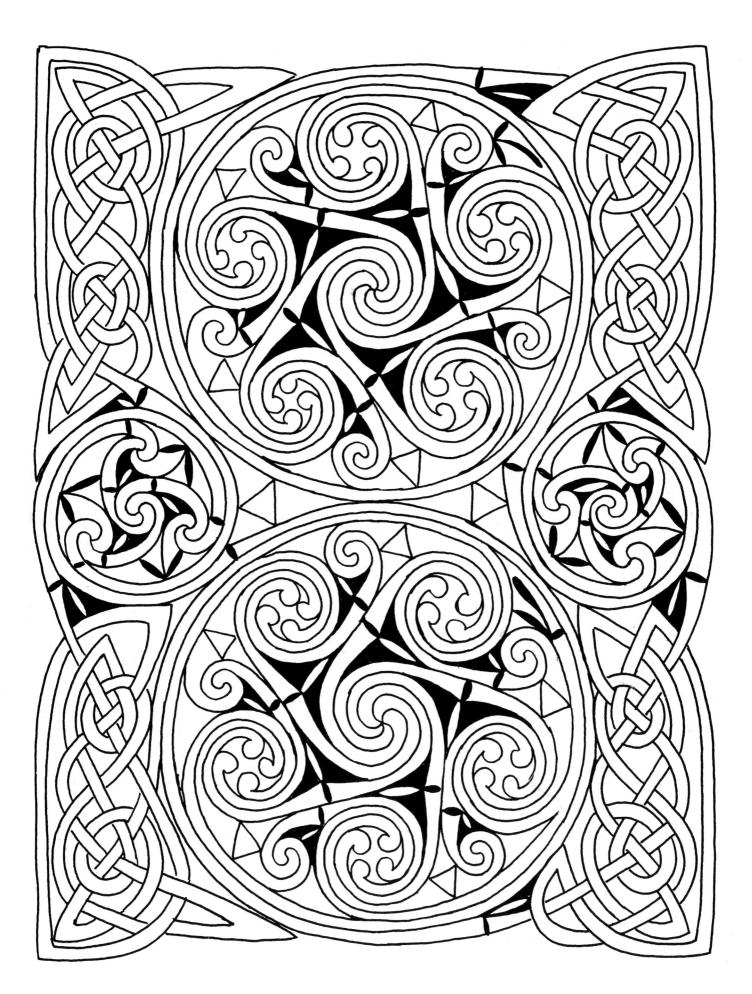

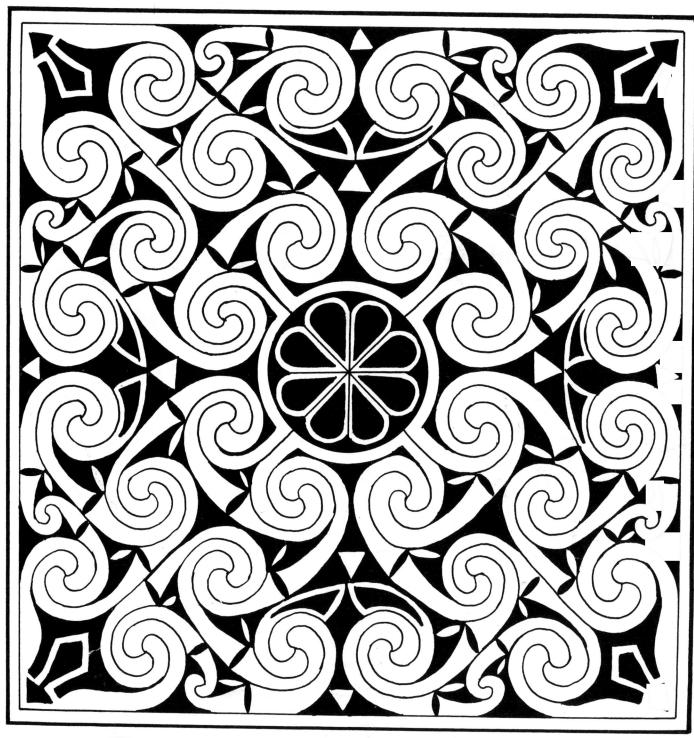

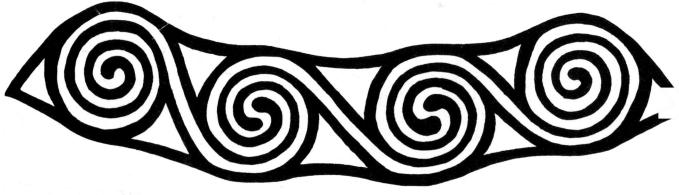

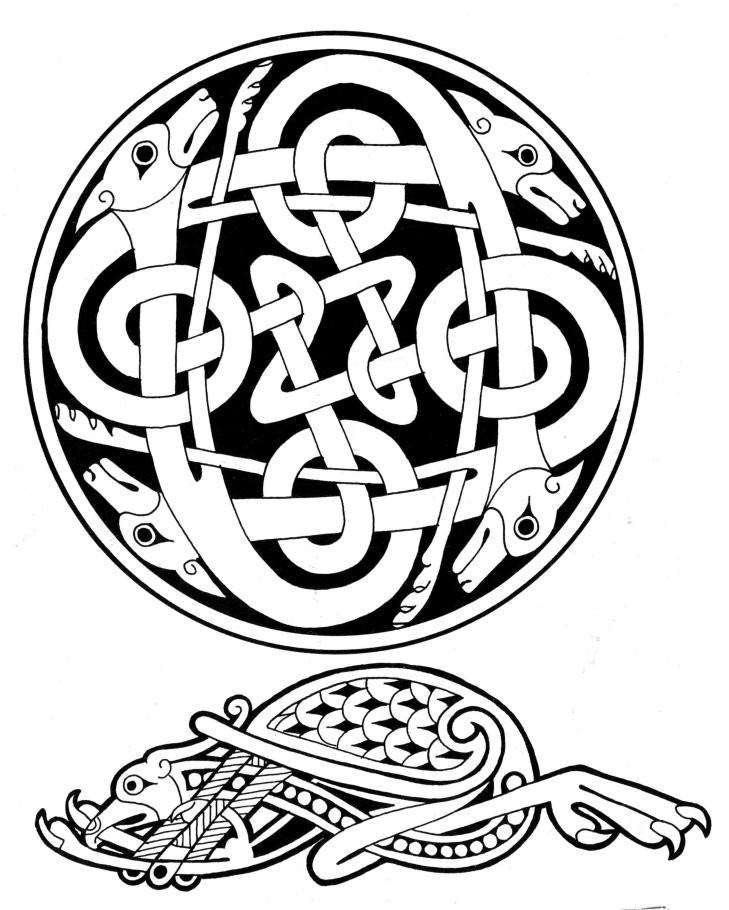

BRAINSE MHEAL RATH LUIRC CHARLEVILLE MALL LIBRARY TEL 8749619

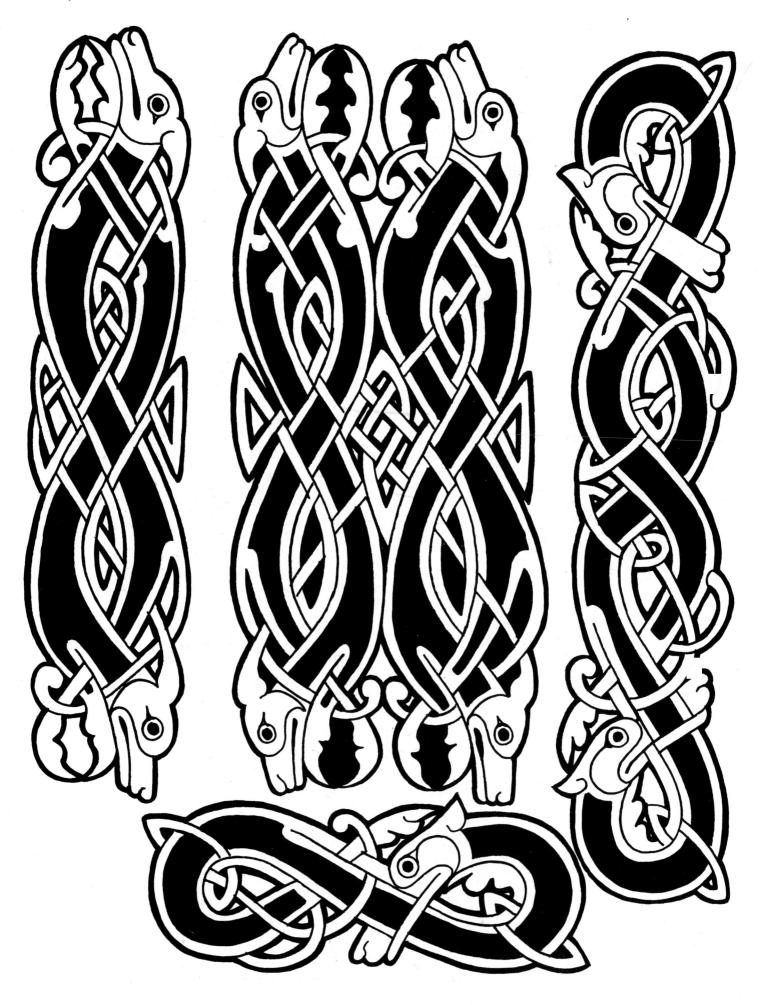

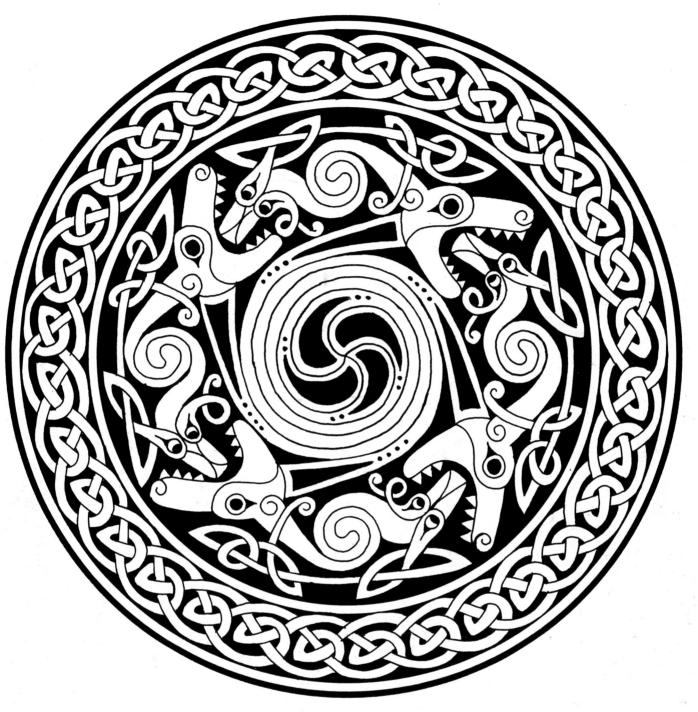

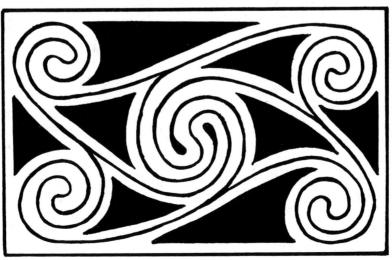

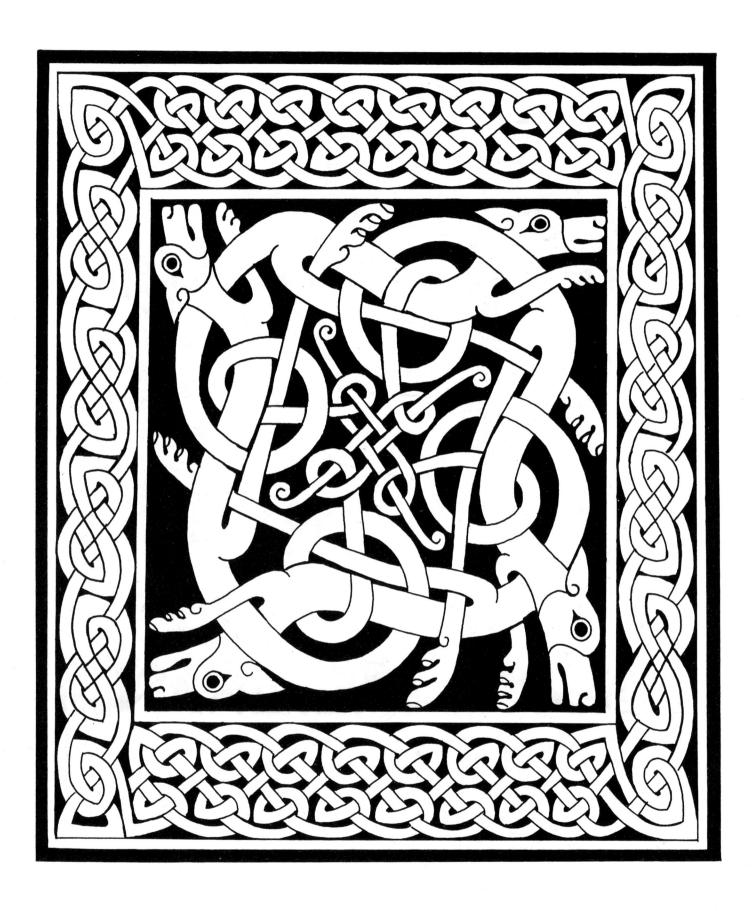

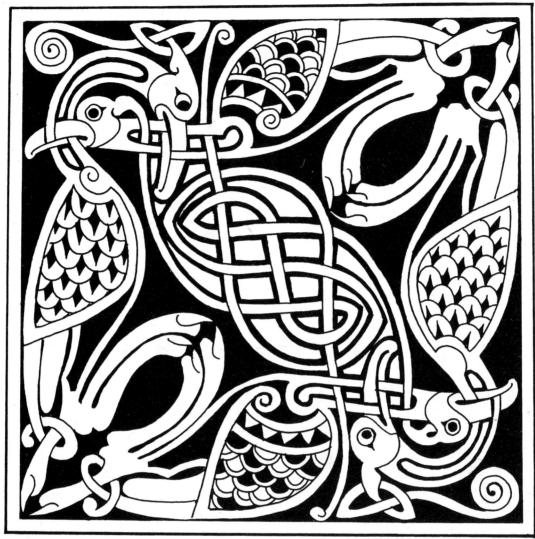

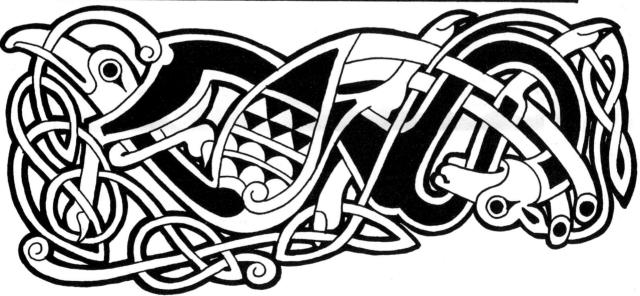

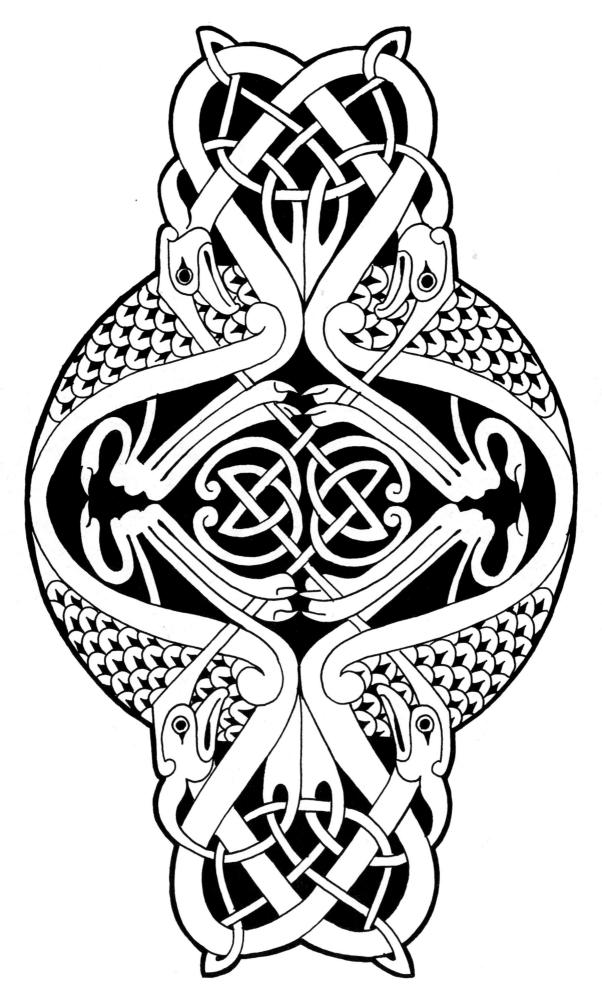

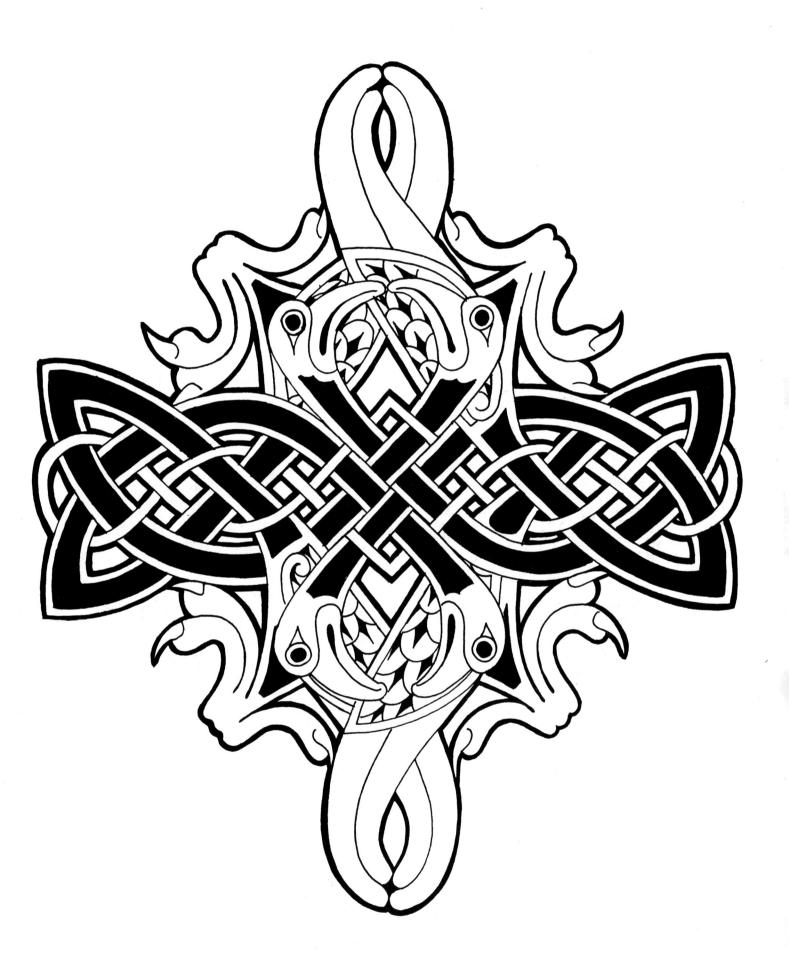

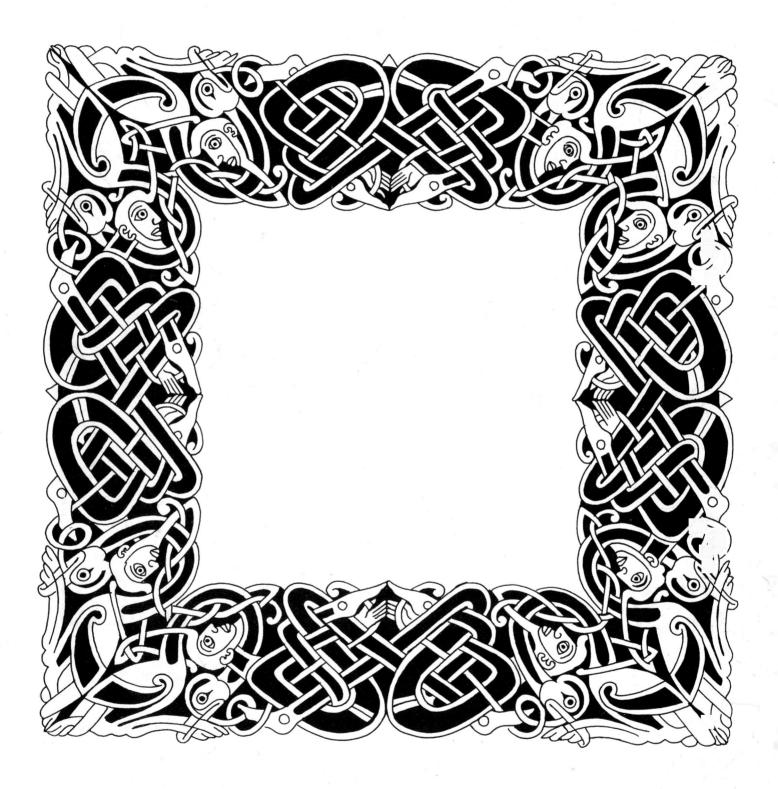

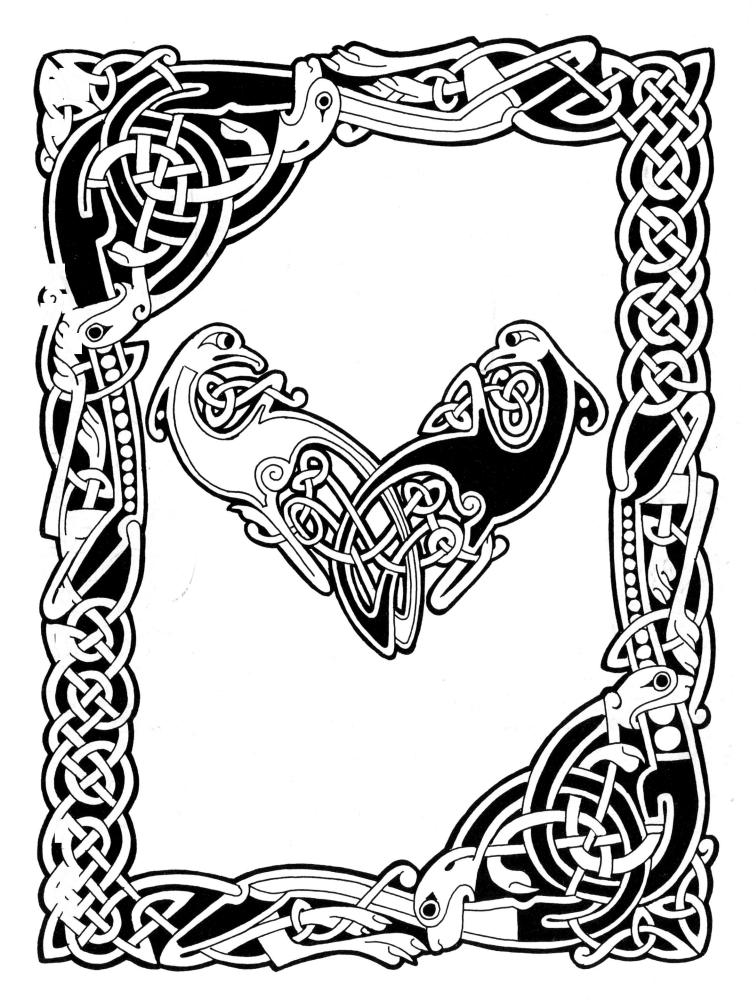

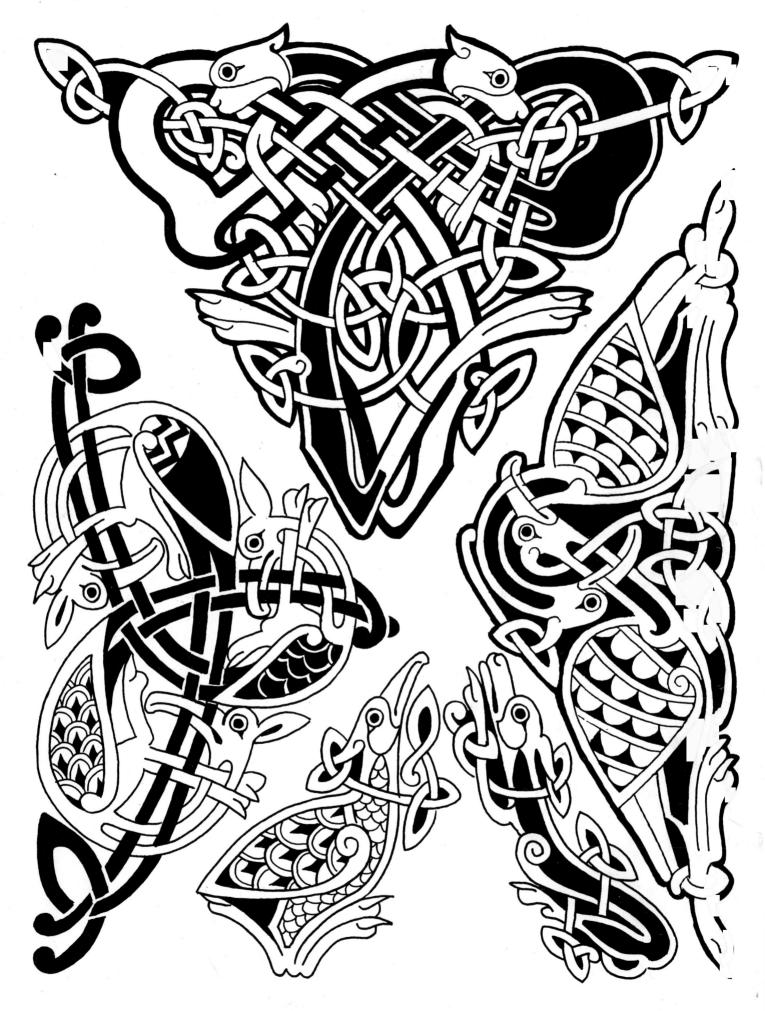